# OUR LOVE OF
# *Loons*

Stan Tekiela

Adventure Publications, Inc.
Cambridge, MN

# Dedication

To Agnieszka Bacal. Your love of nature is as wonderful as the loons themselves.

Photos by Stan Tekiela

Edited by Sandy Livoti

Cover and book design by Lora Westberg

10 9 8 7 6 5 4 3 2 1

Copyright 2014 by Stan Tekiela
Published by Adventure Publications, Inc.
820 Cleveland Street South
Cambridge, MN 55008
1-800-678-7006
www.adventurepublications.net
Printed in China
ISBN: 978-1-59193-495-0

# Symbol of Wildness in the Northland

Loons are marvelous creatures that symbolize the wildness of the Northland. To many of us, a northern lake without a family of Common Loons just wouldn't be the same. I have photographed and studied these birds for many decades and am still thrilled each time I get to observe them. I look forward to their return each spring and mourn the day they leave in autumn. I am not sure if it's their stunning good looks or the haunting calls, but loons seem to endear themselves to us, and for that I am grateful.

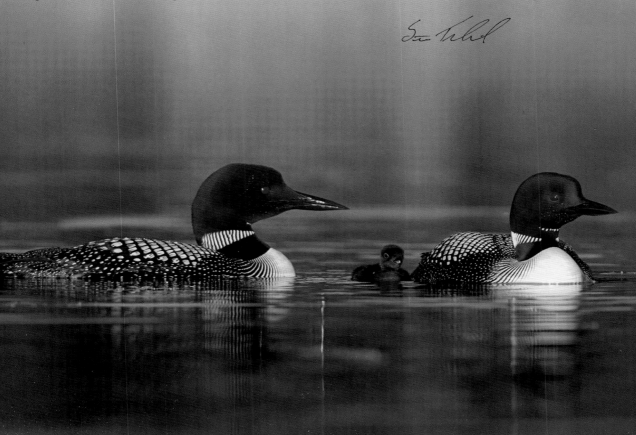

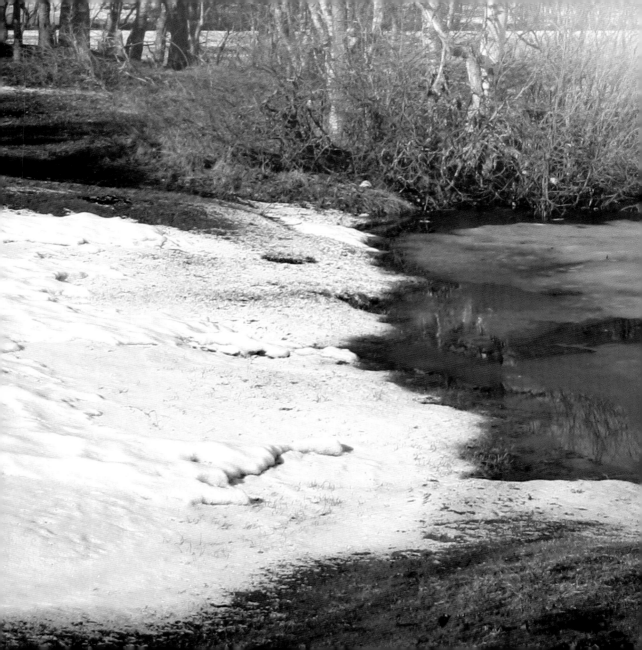

# Ice Out: Loons Return to the Northland

Just when it seems that winter won't give up and the ice won't melt until June, the sun's warming rays and the balmy winds of spring work together to melt the gray grip of ice that blankets the lake. The thick layer of ice that once covered the lake turns dark, suddenly breaks up and melts away. And just like magic, the loons return.

The northward migration of Common Loons depends on the availability of open water. These large aquatic birds are unable to take off from solid surfaces, such as land or ice, so they need to wait patiently for the lakes to change from solid to liquid. During the day they scout for open water farther north and will move up when they find it, but they must turn back if the lakes are still frozen. In many years, the lingering cover of ice stops their northward movement.

# Together Again After a Long Flight

There is a special joy in seeing the male and female reunite, having both survived the long winter and the long flight from the south—as far away as the Gulf of Mexico—where they spent most of their time in drab gray winter plumage. Males typically return before females, and to us, may look a bit lonely until their mate arrives. But upon the return of their mate, a new romance begins as the loons greet each other in a tender and loving way.

With their heads bobbing and weaving, they swim toward each other. Softly they rub their heads together in what looks like necking. Then, dipping their bills into the water, they toss their heads back, gently spraying the water dripping from their beaks. They swim side by side for long distances and appear content with each other.

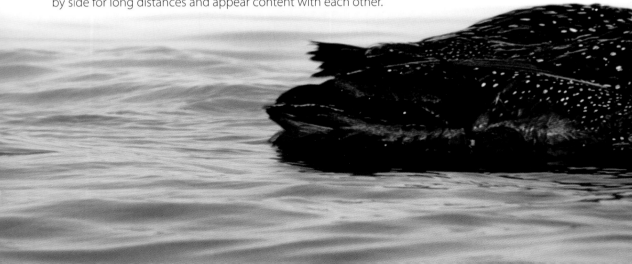

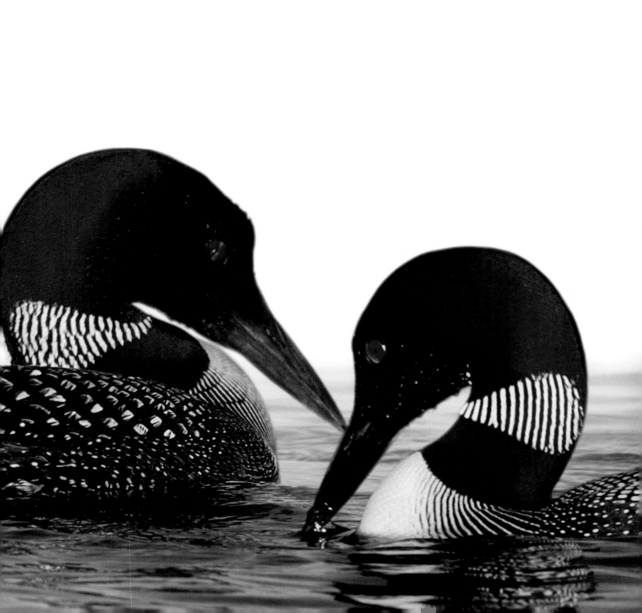

# Are These My Loons?

Is it possible that these are the same loons that were on this very lake last year? Yes, studies of marked loons have shown that if loons were successful at nesting the previous year, their instincts will guide them back to the same lake and usually the same nest the next year. The return of loon pairs to the same lakes is remarkable because mates migrate individually, not as a couple and not in flocks. Loyalty in loons runs strong and deep, with the bond to each other almost as strong as the fidelity to the nest.

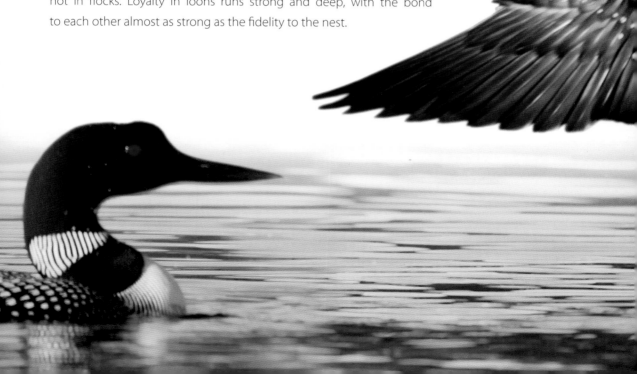

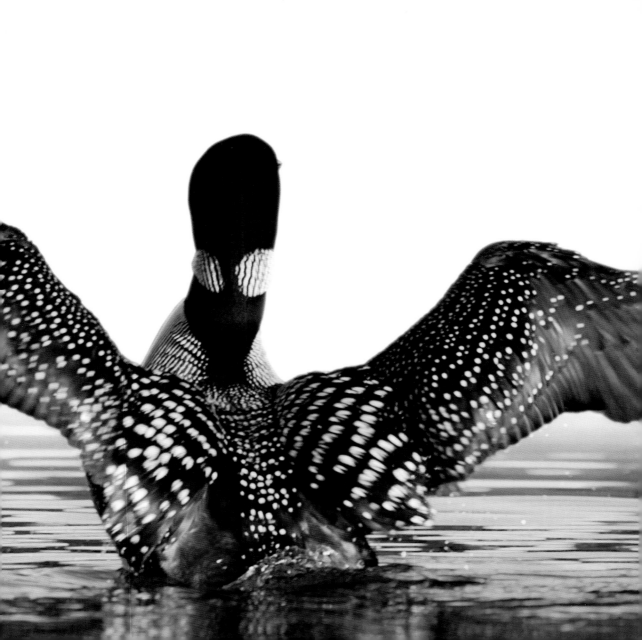

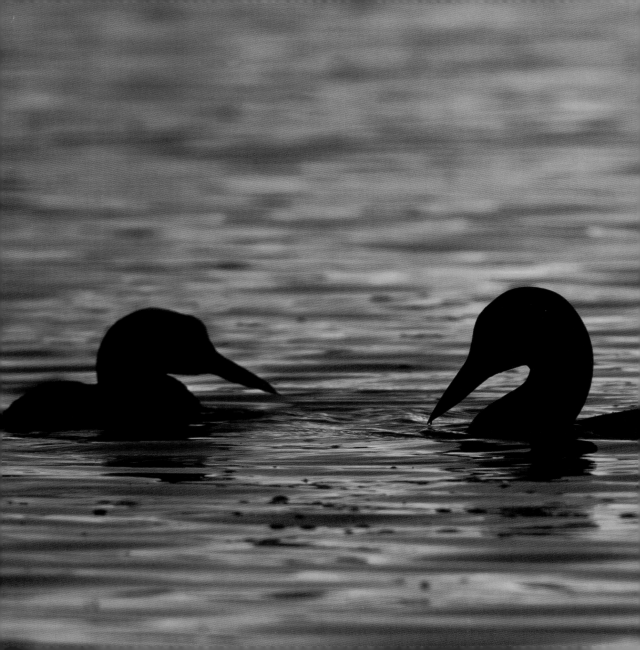

# Do They Really Mate for Life?

The cast of characters at the cabin varies with each visit and each season, but if we are lucky, the ones we hold most dear—our partners—are always present. The same can also be true for loons. If a pair of loons survived the rigors of migration and reproduced successfully the year before, the couple normally stays together for a long time, perhaps a lifetime—and that can be as many as 30 years. But there are no guarantees. If one becomes sick and dies, the survivor will move on, and pick another mate. The new pair will take up residency on the same lake or the surviving loon will move away to find another mate, leaving a vacancy in the territory.

# The More Loons, the Better?

While we would love to see an abundance of loons on our lakes, the population depends on the number of fish available and the clarity of the water. Loons require a lot of territory because they need a large supply of small to medium fish in order to survive and reproduce. The size of a loon's territory is directly related to the abundance of fish. The fewer the fish, the larger the territory. On average, in lakes supporting a healthy fish population, 1–2 pairs of loons will lay claim to about 2 square miles of water. This is a fairly large space for bird territory. If the lake is big enough, other loon pairs will move in next door. Some larger lakes can have up to 8–10 pairs nesting.

# Those Unique, Haunting Calls

There's nothing that says summer at the cabin like the haunting, melodic sounds of loon wails as they echo across the water, bouncing off the trees on the opposite shore. The most active time for loons to call is after dark, when the wind dies down and the water is calm. Most studies of loon vocalizations show that loons call the most after midnight, with adults doing the most calling. The male announces to other loons that he's claiming the area. His call must be loud enough to reach all corners of the territory and beyond to let others know this section of the lake is taken. But they also call to communicate to their mates and young. A certain amount of communication among neighboring loons also goes on during the night.

# Time to Make a Nest—
## Location, Location, Location

It's a suspenseful time of summer for cabin dwellers, wondering if there will be loon babies on the lake this year. Loons prefer to nest on small natural islands—artificial floating platforms are also popular —away from disturbances and predators such as skunks and raccoons. Nests are constructed with easy exits so the loons can slide down directly into the water. Because their legs and feet are located far back on their bodies, loons have difficulty walking. In fact, for first-time parents, this may have been the first time they touched ground in 4 or 5 years. Sometimes loons build nests on top of muskrat lodges. The lodge is like a ready-made nest, without a need to bring in as much nesting material.

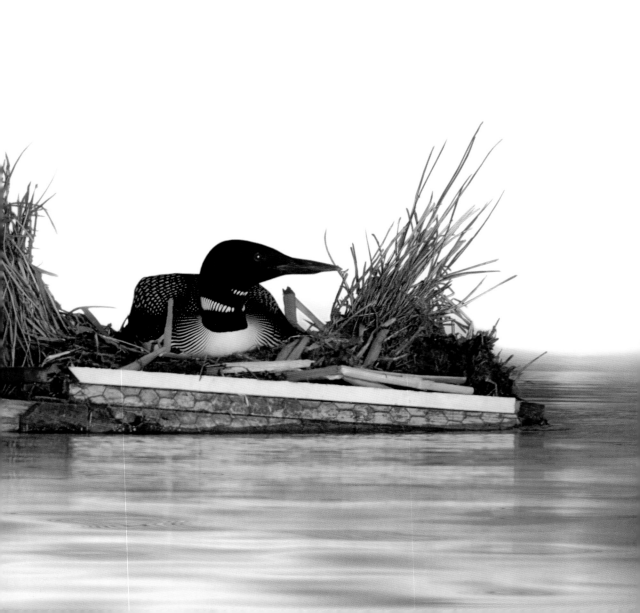

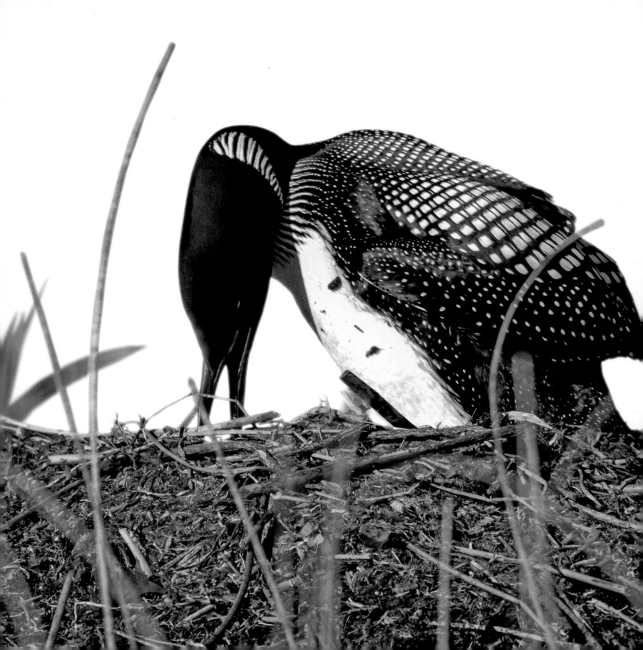

# Building the Nest—a Joint Project

An observant cabin dweller will notice that both parents are suddenly occupied with nest building—gathering rotting grasses, cattail stalks and other aquatic plants from around the nest site. It is a simple process of pulling the soft plants repeatedly to the nest and piling them up to make a soggy mound. They may stack materials as high as 2 feet, which is tall enough to avoid flooding if the lake rises after heavy rain. Inexperienced pairs often build nests too low or too close to the water's edge, with disastrous results. Eggs are deposited in a shallow depression at the top. Successful nests are used year after year. Nesting attempts that fail often mean that the pair will not reuse the nest site. A different pair might use the site successfully, however, and return to it again.

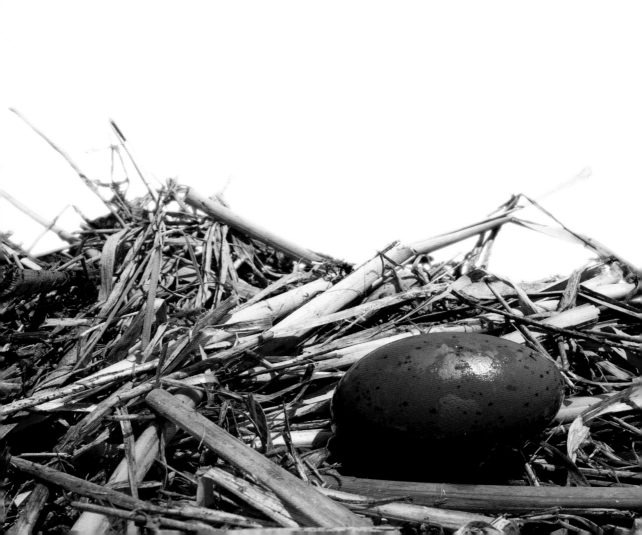

# A Month of Suspense

Now that the nest is ready, will there be a successful hatch? Loons lay two olive brown, speckled eggs each nesting season. They are slightly larger than goose eggs and camouflaged to match the nest. While a sitting parent conceals the eggs most of the time, there are still precious minutes of exposure when the parent leaves to get food or defecate. Thus, it is important for the eggs to blend into the nesting material. The female does the lion's share of incubating, and the male assists when she is temporarily away. The pair sits patiently on the eggs for 4 weeks—nearly a month before the chicks hatch.

# Tiny Fuzzballs Hitching a Ride

By the time fishing season is in full swing, eagle-eyed boaters notice that loons have some fuzzy passengers. Within 24 hours of hatching, baby loons enter the water and begin their lifelong relationship with the wet world. Their brown downy coats allow the babies to float like corks, but they can get waterlogged and need to get out of the water now and then. Starting from day one, they find refuge on the backs of their parents, where they sleep, relax and dry out. When a baby needs some help, it swims alongside a parent, who instinctively raises a wing. The baby swims underneath and clumsily makes its way onto the parent's back, where it rides in safety and comfort. After about 10 days to 2 weeks, they stop riding completely because it becomes too difficult to climb up.

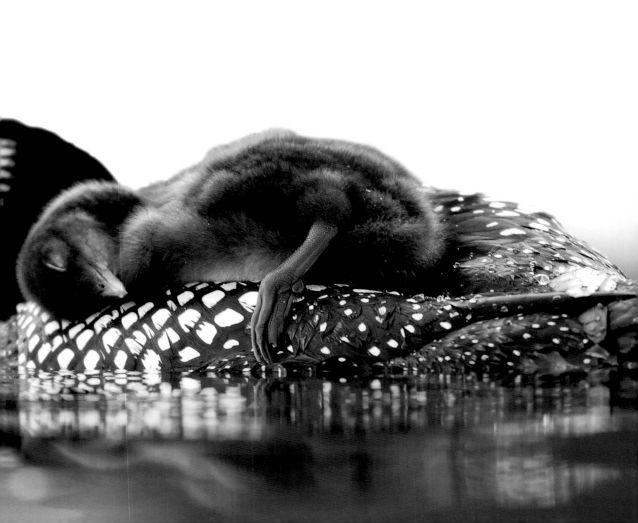

# Those Parents Never Get a Break!

Feeding the babies takes nearly constant fishing and feeding. Adult loons are very large birds, but their size doesn't stop them from gathering the tiniest fish or aquatic insects to feed their babies. Although capable of catching larger fish, they bring surprisingly delicate morsels to give to their young. At first the babies have trouble grasping the food and often drop it. With great patience, the parents will calmly pick up the fish and offer it over and over again. Eventually the young get the hang of this routine and consume the meal. Because of this high protein diet, they grow quickly, reaching 6–8 pounds in just three months.

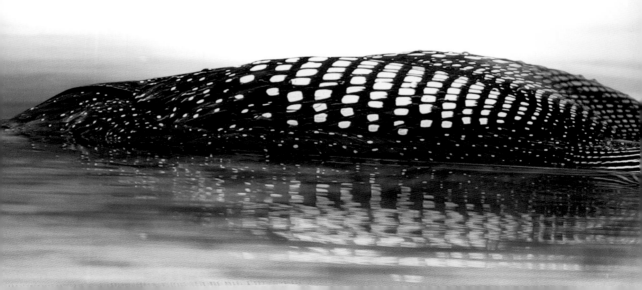

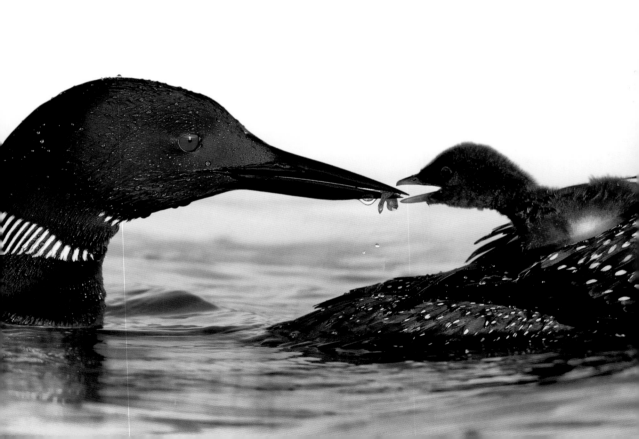

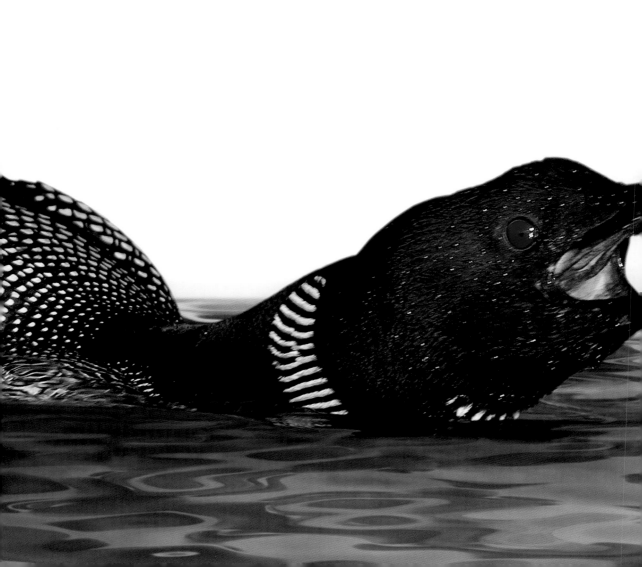

# Loon Parents on Guard

Sometimes the everyday quiet of loons swimming on the lake is broken by agitated parents. They start calling loudly, while splashing and swimming with wings outstretched. Young loons understand this behavior and immediately dive underwater or head for the cover of cattails. The parents may have astutely noticed an eagle, perhaps perched high on a tree, eyeing one of the babies. Growing up as a baby loon is fraught with pitfalls. It seems like every predator, from eagles above to Snapping Turtles and large Northern Pike below, wants to eat them. The babies float on the lake's surface and are often ambushed from beneath. On average, only one of two chicks will survive to adulthood.

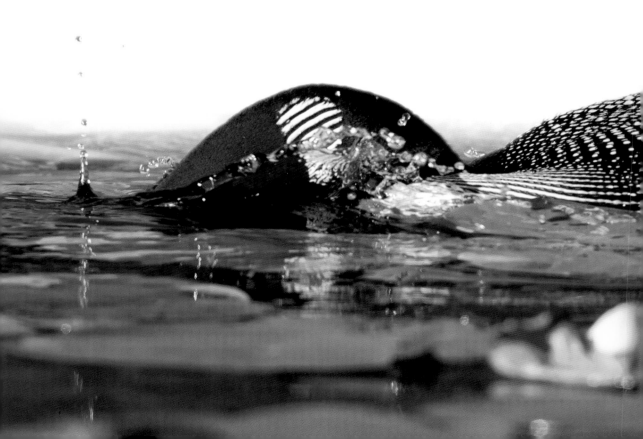

# What Are They Looking At?

If the loon doesn't disappear in a dive, you'll probably notice it dipping just its head underwater, again and again. This behavior, called peering, is extremely common. Loons peer to have a look around and to locate fish, keep track of each other and watch for underwater predators. Juveniles often peer to observe their parents chase and catch fish. Peering usually happens over and over at any time of day, making it an easy behavior for casual watchers to see.

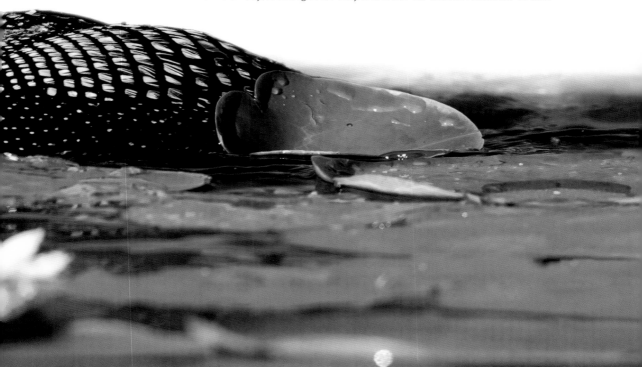

# Now You See Them, Now You Don't

It's very likely that just as you point out the loon to your boat companions, it's gone from sight and it is anyone's guess as to where it will resurface. Loons can stay underwater as long as 30–90 seconds and may surface as far as 1,000 feet from the diving point. When a loon submerges in a flash, it's often on a mission—to catch fish.

For loons, swimming underwater is as natural as flying. But loons don't use their wings to swim or "fly" underwater—their wings stay at their sides. Their body shape allows them to slip through water, and stretching out their necks helps them to cut through water while their powerful feet propel them. Feet on either side of the body enables each stroke to be followed by the opposite foot stroke, maximizing their speed.

# Why Do They Shake Their Foot?

Quite often, loons will raise a foot out of the water and wave it about, almost as if to greet a boat, like waving in a parade. This is foot waggling, an action that conserves heat by shaking off excess water before tucking the foot under a wing to help keep warm. Loons often do this just after preening and before resting. Even young loons only days old perform this behavior.

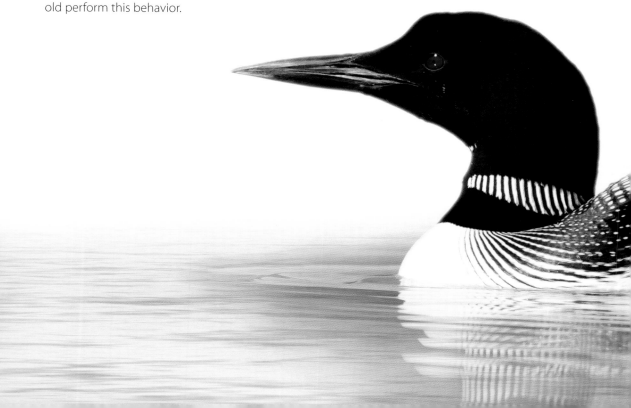

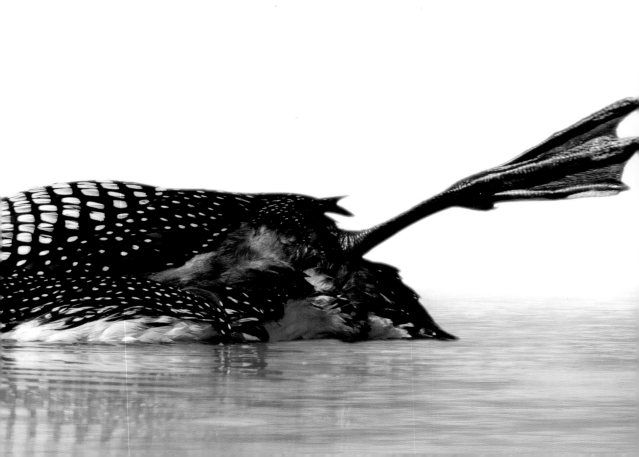

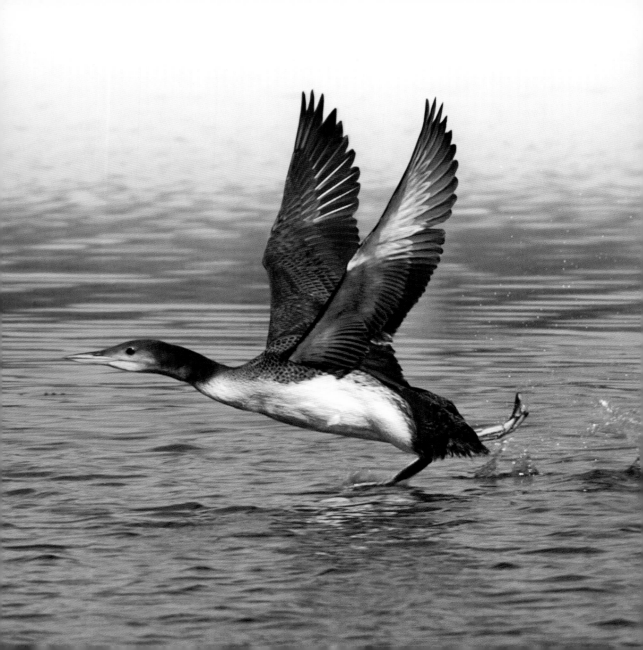

# A Very Entertaining Takeoff!

Sometimes it looks like it takes so much effort for a loon to take off, you hold your breath, hoping it will make it. Taking off and landing is unique in the loon world. Takeoff requires facing into the wind while flapping and running on the water's surface for upwards of 500 feet, depending on the wind's strength. The stronger the wind, the shorter the distance needed. Loons have a wingspan of 5 feet and measure 3 feet from the bill to their feet. Adult males weigh 7–17 pounds, while females weigh 5–14 pounds. To get airborne takes a lot of effort and requires a decent amount of "runway" water, which is one reason you won't find loons on very small ponds.

Landing can be tricky. Loons don't use their feet to cushion the landing, like ducks and geese. Instead, they land on their chests and bellies, skidding on the water's surface. They must hold their wings high and arched over their backs to avoid clipping a wing tip on a wave or hitting the surface, which can result in a crash landing.

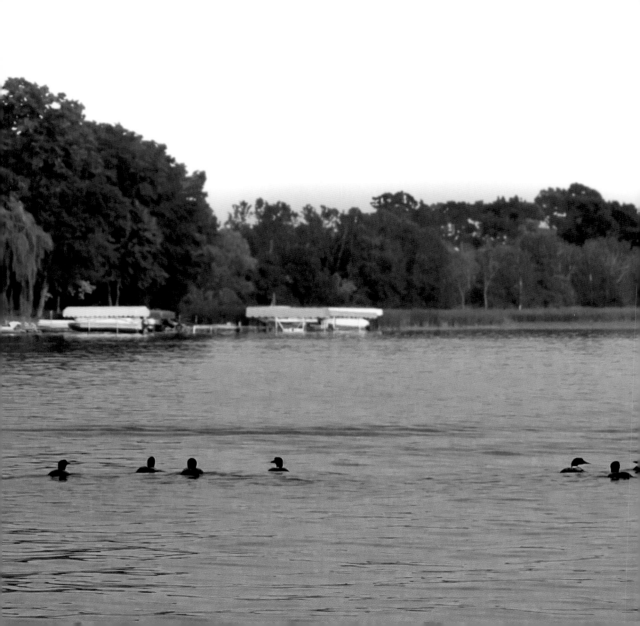

# Where's the Party?

During summer, adult loons gather in small groups for social time. Starting in mid to late summer, up to 20 or more adults meet at a local lake. When pairs of visiting loons start to arrive, the resident loons swim out to meet and greet them. Once everyone is there, they swim toward each other. As they draw close, they cock their heads to one side and swim in tight circles, almost like tango dancing.

Around they go until one suddenly dives underwater, followed by the next. Soon all the loons are underwater. Quickly they pop to the surface and start to preen their feathers. Then they swim near each other and start the process again. This can go on for an hour or more. Social time concludes when loon pairs peel away and take off, heading back to their own lakes. One wonders how they know the place and time for these events . . .

# What? The Young Are Left Behind?

Suddenly one day, near the end of summer, you see that the adults have left and only the young ones, now full-sized birds, are left swimming on the lake by themselves. Instincts drive them to try again and again to fly, just like toddlers are driven to practice walking. In young loons, the urge to fly is as strong as their instinct to swim.

Winter is fast approaching and the young have no choice but to learn to fly or die in the icy grip of the season. They spend many hours swimming to the end of the lake, facing into the wind and running with all their might, each time building strength in their wings. Eventually, they will get off the water's surface for a short distance before skittering to a splashy stop. Then they will swim back to the windward side of the lake to practice their takeoff all over again.

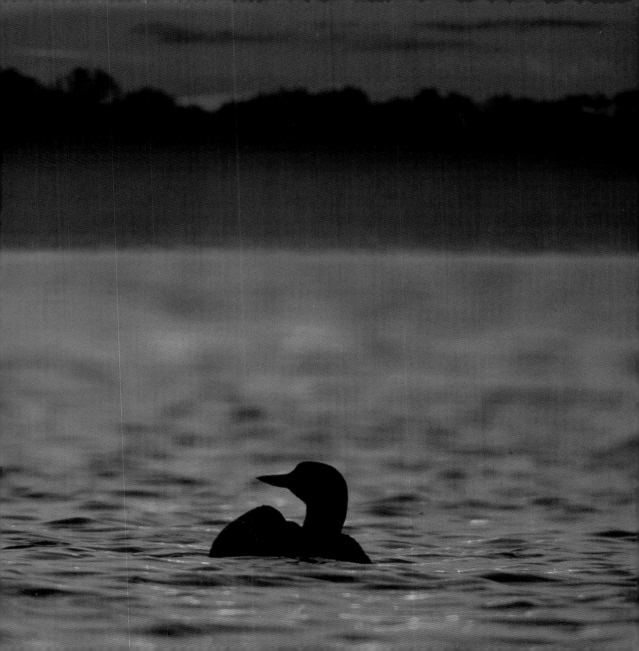

# Casual Clothing: Changing Colors for Winter

The fine black-and-white plumage of the Common Loon has purpose. Showing off impeccable patterned feathers indicates the individual's health and potential as a mate. Once mating season is over, however, the need to impress is not necessary. Adults without babies or those whose babies perished will start to molt first. Adults with living babies molt later, just before migration.

Starting with the face, gray feathers begin to replace the black feathers. By migration time, the adults have molted their bold patterns and look more like juveniles than adults. They will fly south and spend the winter coated in gray-and-white feathers. Starting in late winter they start to molt back into their fine black-and-white formal wear.

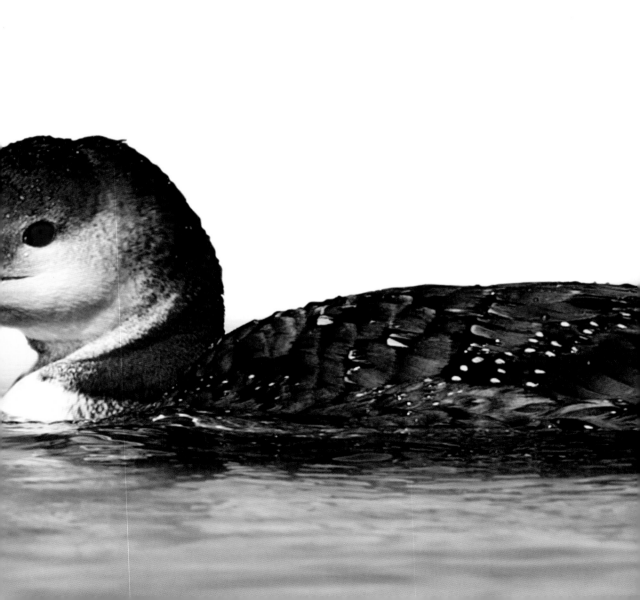

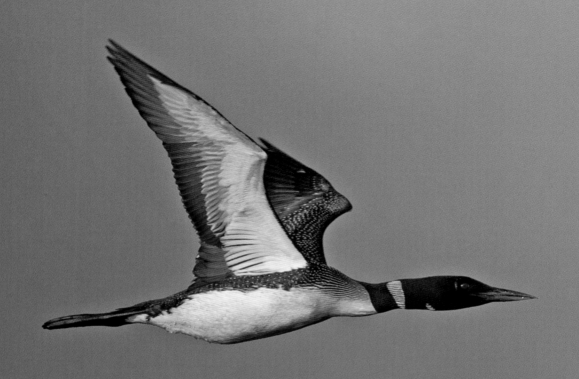

# Where Do They Go During Winter?

Just as our lake neighbors may be "snowbirds" and head south for the winter, so do our loons. Research that involved fitting electronic devices on loons revealed the secret of where they spend the winter. Most in the upper Midwest fly to the Gulf of Mexico. Some stop migrating earlier and stay in freshwater reservoirs in Tennessee, Kentucky and Mississippi. Loons in such places as New York and New Hampshire fly to the Atlantic side of Florida. Loons in other northern environments, such as Maine and Canada, just fly to the coast and spend their winters in icy ocean waters before making the short return in spring to their freshwater lakes.

Wintering in the Gulf of Mexico or the Atlantic Ocean may not seem abnormal, but it is extraordinary that loons can change from a diet of fish in freshwater to saltwater. Dealing with saltwater has challenges all its own. Few birds make this transition in their lifetime, let alone twice a year. Loons are highly adapted to tolerate and excrete the extra salt. Specialized glands near their eyes do this job well.

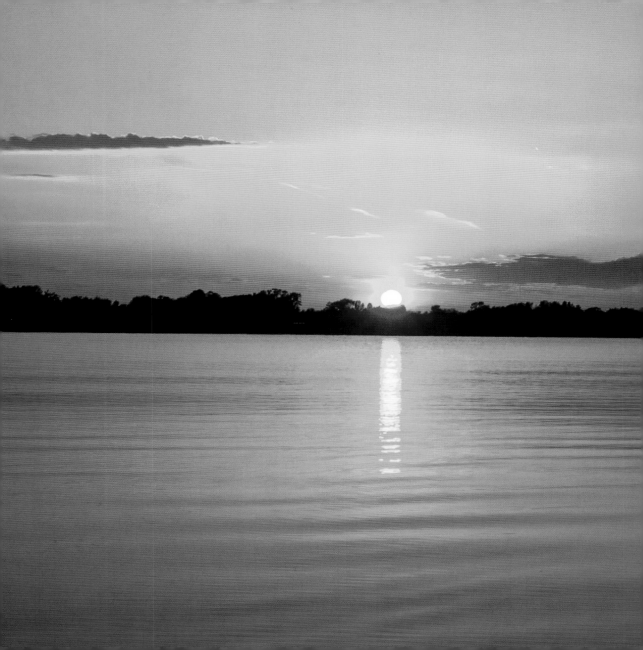

# Looking Forward to Their Return

Taking out the dock signals the end of another enriching season at the cabin. The lake is once again peaceful and calm. The loons have left for warmer weather and water that won't turn to ice—a place where they can chase and catch fish. It won't be long before frigid temperatures will cap our favorite lake in ice, and as a result, hold the lake in suspended animation until the following spring, when we will once more look forward to the return of our loons.

# Observation Notes:

Date:

_____   _____

_____   _____

_____   _____

_____   _____

_____   _____

_____   _____

_____   _____

_____   _____

_____   _____

_____   _____

_____   _____

_____   _____

_____   _____

_____   _____

_____   _____

# About the Author

Naturalist, wildlife photographer and writer Stan Tekiela is the originator of the popular nature appreciation book series that includes loons, eagles, bluebirds, owls, hummingbirds, woodpeckers, wolves and bears. For about three decades, Stan has authored more than 120 field guides and wildlife audio CDs for nearly every state in the nation, presenting many species of birds, mammals, reptiles and amphibians, trees, wildflowers and cacti. Holding a Bachelor of Science degree in Natural History from the University of Minnesota and as an active professional naturalist for more than 25 years, Stan studies and photographs wildlife throughout the United States and has received various national and regional awards for his books and photographs. Also a well-known columnist and radio personality, his syndicated column appears in more than 20 newspapers and his wildlife programs are broadcast on a number of Midwest radio stations. Stan can be followed on Facebook and also Twitter. He can be contacted via his web page at www.naturesmart.com.